SOUTHWEST INDIAN DESIGNS

With Some Explanations

BY MARK TOMAS BAHTI

Published by
Treasure Chest Books, LLC
P. O. Box 5250
Tucson, Arizona 85703-0250

Copyright © 1994, © 2001 by Mark Bahti

Printed in Canada
Printing 10 9 8 7
ISBN 0-918080-98-3

Introduction

This book is an attempt to address questions people have about some of the more frequently seen Southwest American Indian designs. It is important to understand that while symbols can be used as designs, not all designs are symbols: everything does not have to 'mean' something.

Romanticization of the American Indian began in earnest towards the end of the 1800s, after they no longer posed a military threat to U.S. expansion. Eastern tourists, traveling west on the Santa Fe Railroad and staying in the Harvey Houses along the way, were eager to buy souvenirs – mostly Indian-made souvenirs. Their interest often extended to wanting to know what the designs meant on pottery, baskets, rugs and jewelry. This is an example of responses to that curiosity:

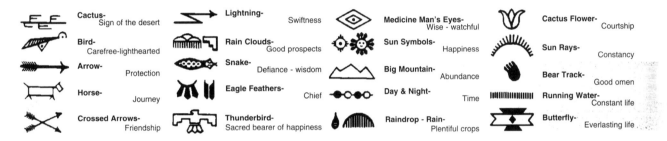

Cactus- Sign of the desert

Bird- Carefree-lighthearted

Arrow- Protection

Horse- Journey

Crossed Arrows- Friendship

Lightning- Swiftness

Rain Clouds- Good prospects

Snake- Defiance - wisdom

Eagle Feathers- Chief

Thunderbird- Sacred bearer of happiness

Medicine Man's Eyes- Wise - watchful

Sun Symbols- Happiness

Big Mountain- Abundance

Day & Night- Time

Raindrop - Rain- Plentiful crops

Cactus Flower- Courtship

Sun Rays- Constancy

Bear Track- Good omen

Running Water- Constant life

Butterfly- Everlasting life

Symbols were developed before written language to express ideas that were understood and accepted by the groups that used them. Just as symbols preceded language, so they still exert a powerful hold on our imaginations and attention.

Even today in Western culture the symbol can be more powerful, more compelling than the written word and understood more clearly and quickly. We do not need to read the letters STOP in a ⬡ to know what to do.

Interestingly, symbols generally remind us of a word, but a word rarely reminds us of a symbol. 🏴 may make us think of America, but the word America does not necessarily make us think of a 🏴 .

And symbols do not necessarily mean the same thing even to people of the same culture. To one person, Ⓧ may remind them of a certain make of automobile, while another thinks of the peace movement.

So it is with the American Indian designs and symbols, but because there is a tendency to

forget that there are many different American Indian cultures, there are attempts to assign a single meaning to a particular design. A 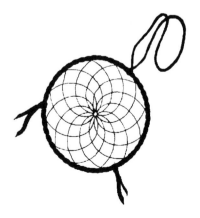 or do not have the same significance to the Hopis as they do to the Navajo. Similarly, a has a different role in Navajo religion than it does in Lakota religious stories. Among the Hopi the significance is different yet and among the Pima it has no role at all.

It is as easy to over-complicate as it is to over-simplify: are often used to symbolize clouds, but that does not mean that every time a Pueblo Indian artist uses a \triangledown that the intent was to invoke the image of clouds, any more than a \triangle is meant to represent an Egyptian .

Cultures change over time. The significance attached to certain symbols can change or be lost altogether. When a culture shifts from a hunting to an agricultural economy, hunting animals become less important. Ideas can become as obsolete as technology can.

New ideas, new designs or new interpretations of old designs occur all the time. In recent years, as marketing efforts, non-Indians have created a number of stories that are represented as traditional Indian stories. Perhaps the most pervasive currently is that of the so-called 'dream catcher', which has been variously attributed to the Ojibway, the Lakota and the Oneida, among others. Among some Athabascan groups, a spider figure named Iktomi is a powerful personage and the spider web was revered for being able to allow bullets or arrows to pass through with no harm to the web. For this reason a warrior might choose to wear a small representation of Iktomi's web into battle, but the Dream Catcher story claims that bad dreams somehow pass through the spider-web-like design and only the good dreams are caught and dreamt. Another version is that it catches the bad dreams and lets only the good dreams pass on to the sleeper. The story, however entertaining, is neither traditional nor Indian in origin.

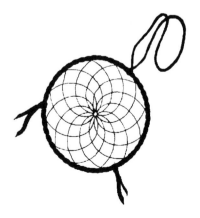

Author's Note

At the end of this book is an annotated bibliography of sources for American Indian designs. One cautionary note: these designs were developed long before the concept of copyrights. Artists working today, license or otherwise protect their work from blatant plagiarism. Rare is the company that would try and use an artist's work without permission, or even more rarely, borrow the logo of another firm, but rarer still is the business that uses an American Indian religious symbol with the same consideration.

While *currently* there might not be legal considerations in copying a Navajo sandpainting, for example, as a business logo or on a greeting card, there *are* ethical considerations. Let your good conscience be your guide.

Note: A portion of the proceeds from this publication have been earmarked for the American Indian Scholarship Fund at the University of Arizona, Tucson, Arizona 85721

Nazha, often spelled *naja*, is a Navajo word translated as "crescent." The Navajo first saw this design on Spanish silver bridles, where it was used to ward off the evil eye, a tradition originating with the Moors. This moon-like motif was adapted by the Navajo for use as a pendant on a necklace. The hands on this naja evolved from the Moorish Hand of Fatima. The *fleur-de-lis* design at its center was readily adopted by the Navajo for whom it was a variant of a young corn plant design.

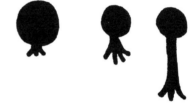

What we identify today as a squash blossom is in fact a Navajo adaptation or evolution of the pomegranate blossom, the emblem of the Spanish city of Granada. Silver pomegranates were occasionally worn by Spanish gentlemen. Despite stories to the contrary, the number of petals is solely a matter of the silversmith's artistic discretion.

Though other names in English have been given to this design, in Zuni it is called *shu'kuh-tu-li-atsi-nan*, which has been loosely translated as 'double-split stitch,' a purely descriptive name.

An early ethnographer working among the Hopi identified these designs as representing a type of prayer offering made of handspun cotton string with feathers attached. More recently, Hopi potters have identified them as a type of fringe found on rain sashes worn by traditional Hopi brides and certain Hopi katsinas.

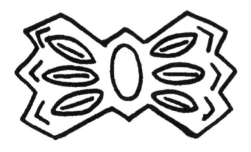

Some Navajo concha belts are made with spacers called butterflies alternating between the conchas.

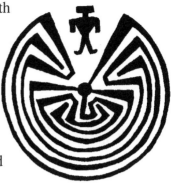

This Tohono O'odham design originally was meant to show the path that a creator figure called Elder Brother, or *I'itoi*, took to his home beneath Baboquivari Peak in order to elude anyone who might follow him. The Pima also use this design. For them, it represents the floor plan of the home of Elder Brother.

In the past century, the story most often heard describes this design as the path of life, though there is some disagreement as to whether the figure is entering or leaving the maze. The design lends itself well to the path-of-life interpretation as it has no shortcuts, no dead ends, and the entire path must be followed in order to complete the journey.

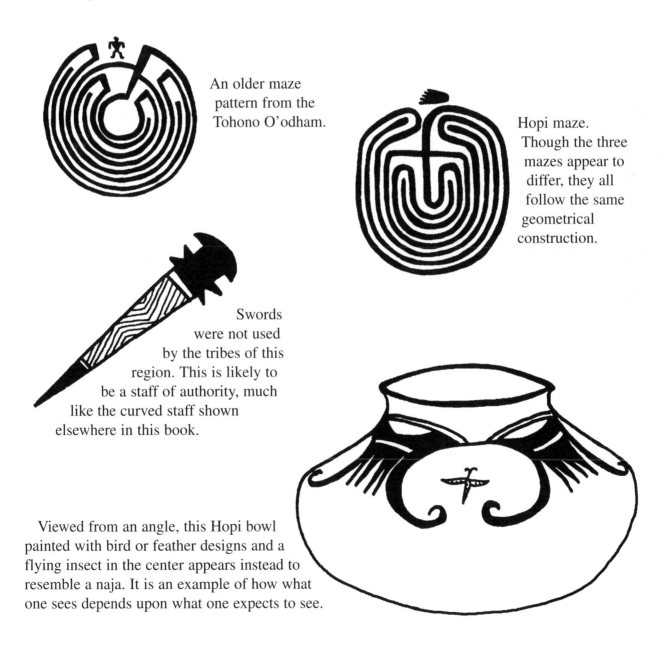

An older maze pattern from the Tohono O'odham.

Hopi maze. Though the three mazes appear to differ, they all follow the same geometrical construction.

Swords were not used by the tribes of this region. This is likely to be a staff of authority, much like the curved staff shown elsewhere in this book.

Viewed from an angle, this Hopi bowl painted with bird or feather designs and a flying insect in the center appears instead to resemble a naja. It is an example of how what one sees depends upon what one expects to see.

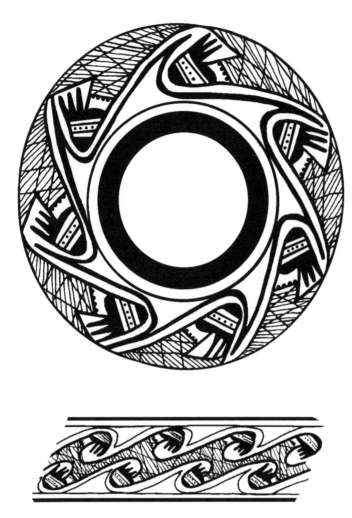

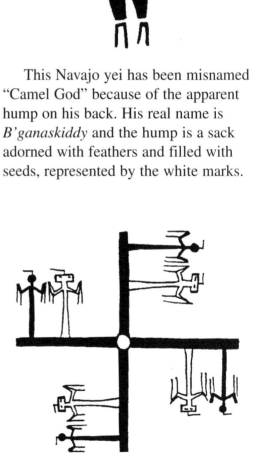

This Navajo yei has been misnamed "Camel God" because of the apparent hump on his back. His real name is *B'ganaskiddy* and the hump is a sack adorned with feathers and filled with seeds, represented by the white marks.

A Hopi pottery design once identified as a bird wing motif, but recently renamed a "migration design" by a Hopi potter.

The design called a swastika used to appear frequently in Navajo rugs, Apache baskets, and Hopi rattles.

The design to the far left is a cross with feathers attached - a symbol from a Navajo ceremony called "The Hail Chant."

A Navajo sandpainting design called "Whirling Logs."

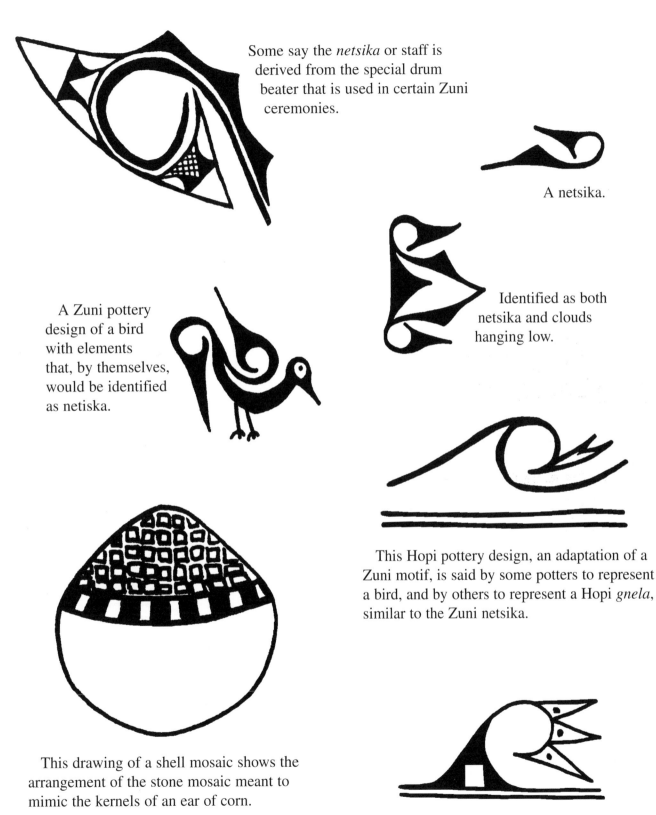

Some say the *netsika* or staff is derived from the special drum beater that is used in certain Zuni ceremonies.

A netsika.

A Zuni pottery design of a bird with elements that, by themselves, would be identified as netiska.

Identified as both netsika and clouds hanging low.

This Hopi pottery design, an adaptation of a Zuni motif, is said by some potters to represent a bird, and by others to represent a Hopi *gnela*, similar to the Zuni netsika.

This drawing of a shell mosaic shows the arrangement of the stone mosaic meant to mimic the kernels of an ear of corn.

A netsika found at San Ildefonso.

The original of this Zuni design was painted in red and black, meant to represent a flower design to some and a prayer for a beautiful summer to others - ideas that are not entirely dissimilar.

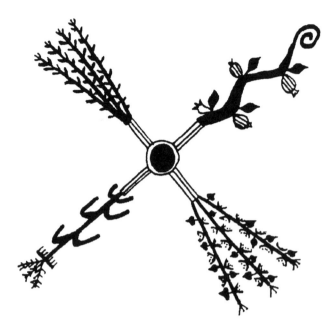

From a Navajo sand painting design, the four sacred plants: squash, beans, corn and tobacco - the latter used in purification.

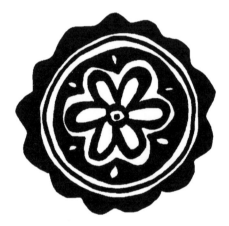

Hehpakinneh - a Zuni sunflower design, usually painted in red and black.

 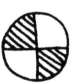

The circle with the cross is a Hopi flower design, while the other two are said to represent corn. The bowl holds ground corn.

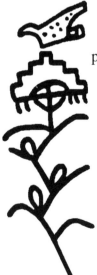

This bird, corn and rain cloud petroglyph design is very similar to the Navajo sandpainting on the next page.

Depending upon the orientation of the viewer, this Hopi design can appear to be either a stylized bird or a young squash plant with the blossom still attached.

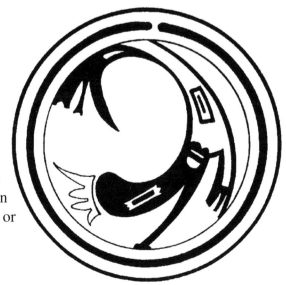

Navajo designs used on both belt buckles and *ketohs*, bowguards used to protect the wrist from the snap of the bowstring.

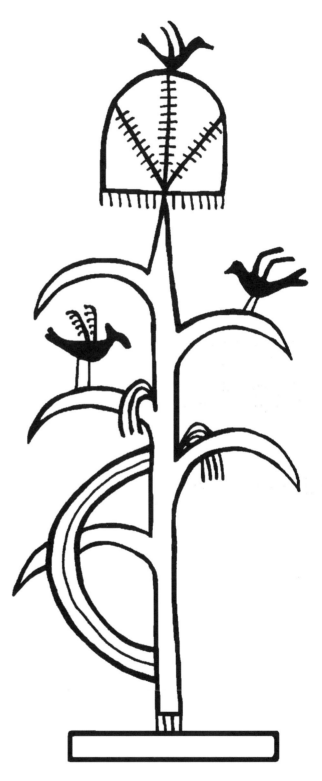

This design from a San Ildefonso pottery rim motif is similar to the two Navajo designs. They appear to be, but are not necessarily, plant-inspired motifs.

Navajo sandpainting design from the Blessing Way ceremony, consisting of birds resting on a corn plant with pollen-filled tassels at the top and a rainbow on the stalk.

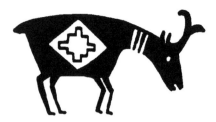

Mimbres pottery antelope design.

J.W. Fewkes, an ethnographer working in the Hopi villages nearly a century ago, recorded these pottery and weaving designs as butterfly symbols.

It is the long tail, curving over the back that distinguishes this animal petroglyph design as a mountain lion.

Bear tracks have five relatively short claws, though often they are represented as having only four claws.

This Zuni pottery designed has been identified as both a dragonfly and a butterfly.

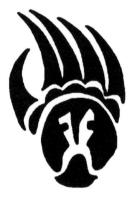

The badger is associated with healing among many Pueblo Indian groups because it lives underground and is therefore familiar with the roots of various plants that have healing properties. It should not, however, be thought of as simply a symbol of or for health. In this particular badger paw design, with its long claws, prayer feather motifs have been used in the palm of the paw.

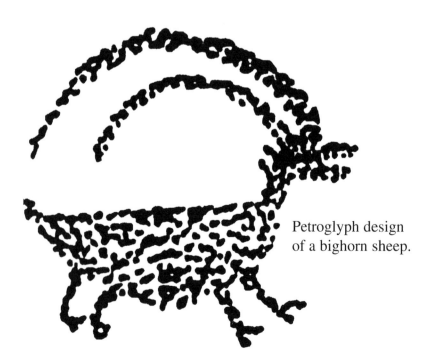

Petroglyph design of a bighorn sheep.

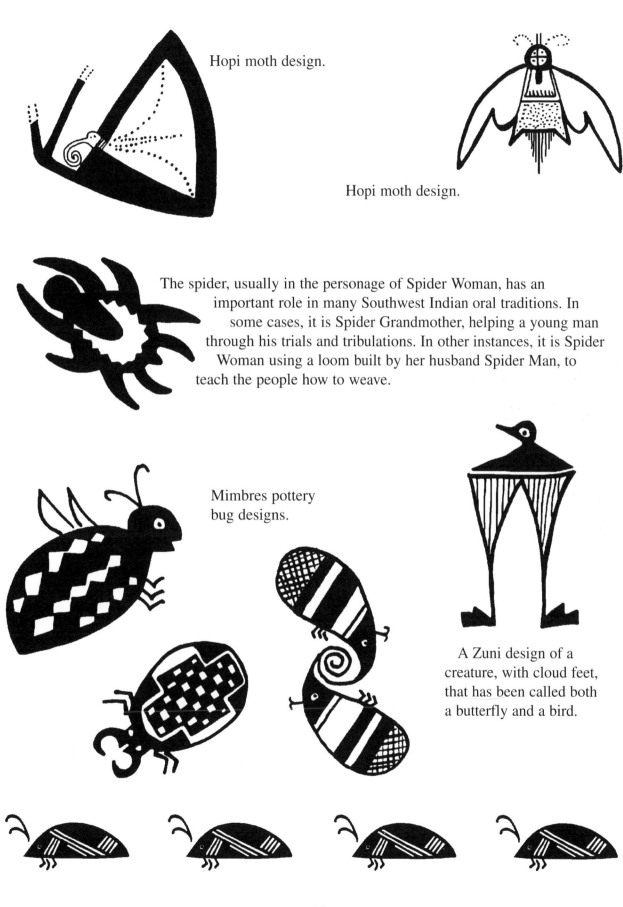

Hopi moth design.

Hopi moth design.

The spider, usually in the personage of Spider Woman, has an important role in many Southwest Indian oral traditions. In some cases, it is Spider Grandmother, helping a young man through his trials and tribulations. In other instances, it is Spider Woman using a loom built by her husband Spider Man, to teach the people how to weave.

Mimbres pottery bug designs.

A Zuni design of a creature, with cloud feet, that has been called both a butterfly and a bird.

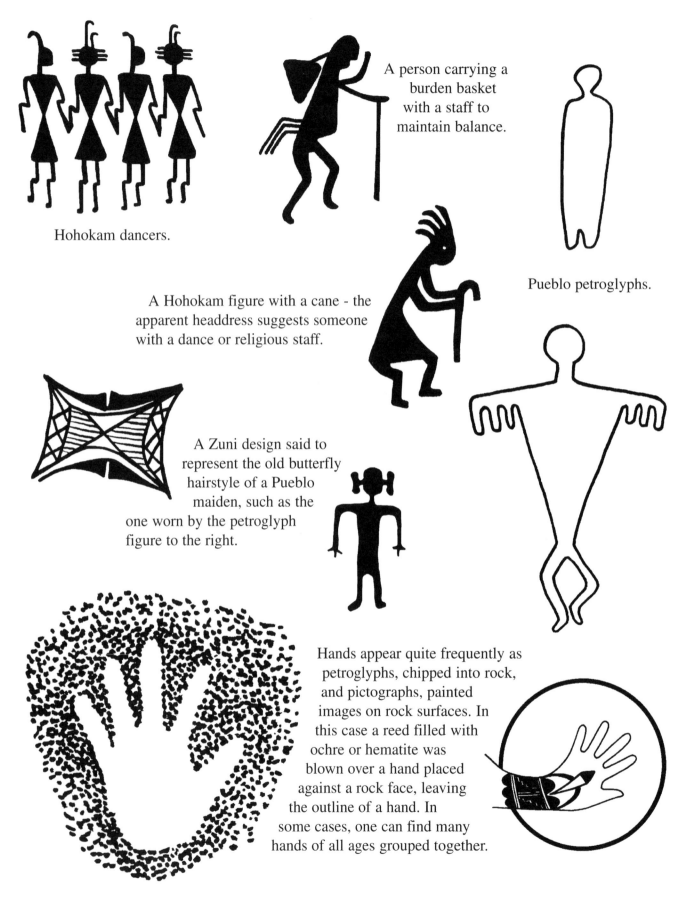

Hohokam dancers.

A person carrying a burden basket with a staff to maintain balance.

A Hohokam figure with a cane - the apparent headdress suggests someone with a dance or religious staff.

Pueblo petroglyphs.

A Zuni design said to represent the old butterfly hairstyle of a Pueblo maiden, such as the one worn by the petroglyph figure to the right.

Hands appear quite frequently as petroglyphs, chipped into rock, and pictographs, painted images on rock surfaces. In this case a reed filled with ochre or hematite was blown over a hand placed against a rock face, leaving the outline of a hand. In some cases, one can find many hands of all ages grouped together.

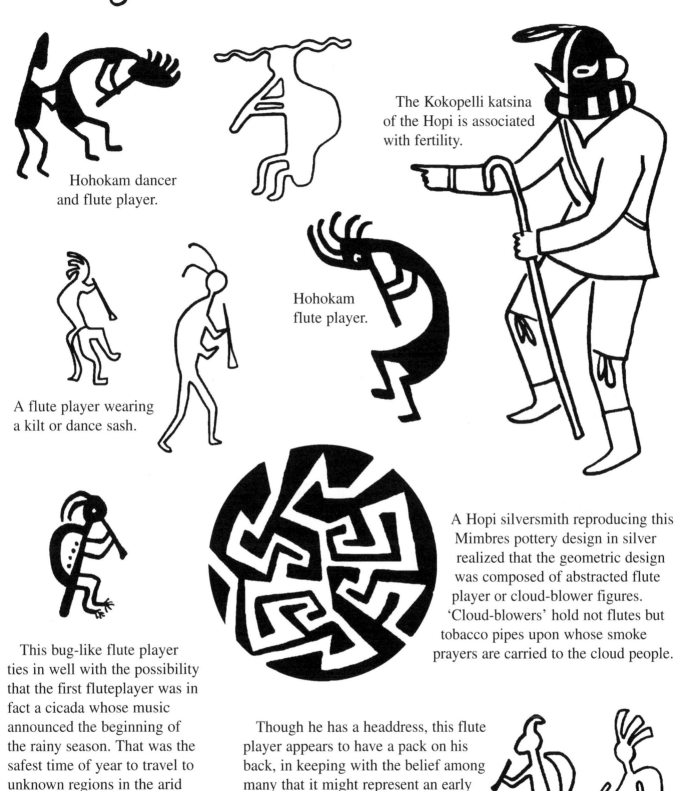

Hohokam dancer
and flute player.

The Kokopelli katsina
of the Hopi is associated
with fertility.

A flute player wearing
a kilt or dance sash.

Hohokam
flute player.

A Hopi silversmith reproducing this
Mimbres pottery design in silver
realized that the geometric design
was composed of abstracted flute
player or cloud-blower figures.
'Cloud-blowers' hold not flutes but
tobacco pipes upon whose smoke
prayers are carried to the cloud people.

This bug-like flute player
ties in well with the possibility
that the first fluteplayer was in
fact a cicada whose music
announced the beginning of
the rainy season. That was the
safest time of year to travel to
unknown regions in the arid
Southwest. It is logical to
assume that many migrations
took place during the rainy
season or very shortly
thereafter.

Though he has a headdress, this flute
player appears to have a pack on his
back, in keeping with the belief among
many that it might represent an early
trader carrying his wares from one
village to another. An active trading
network in the prehistoric Southwest
linked it to the Pacific, the Gulf Coast
and the civilizations of central Mexico.

Hopi bird design flanked by two abstract bird designs.

Claiming both earth and sky as their domain, birds have long been important to tribes in the Southwest. Hawks and eagles, because of their ability to soar into the clouds are often assigned the role of messengers, yet smaller, 'lesser' birds have roles. In several Pueblo Indian emergence stories, it is a small bird that succeeds where the more powerful failed by finding the entrance in the sky from the underworld into the next world.

These Pueblo pottery designs help illustrate the evolution of an abstract double bird design.

Called an *anhinga*, water turkey, and snake bird, this bird is best known as the peyote bird because of its close association with the Native American Church and its sacramental use of peyote.

The peyote bird on the right contains a variety of symbols important in the Native American Church: a head that resembles a rattle, wings reminiscent of the crescent-shaped altar made during each ceremony, the tipi where observances are often held, and the cross of the church itself.

Among the Tewa Indians, the 'sky band' is thought of as the backbone of the sky.

Hopi bird and sky band.

Hopi bird attached to sky band.

Hopi *Sikyatki* bird design.

This Mimbres bird design can also be viewed as four flower motifs that define four bird shapes.

Old Hopi bird designs.

Acoma bird design.

An Acoma bird design, said by most to represent a parrot, but claimed by some to be a chicken.

Mimbres fish design.

Zuni frog or water creature.

Polliwogs are a frequently used Pueblo design, as the polliwog is one of the first reliable signs that the rainy season, a important event in the arid Southwest, has begun.

A Zuni water creature, probably a frog, underneath a raincloud. There is a type of frog in the Southwest that hibernates until the first hard summer rain. Their sudden appearance gives the impression that they fell with the rain.

The double-barred Cross of Lorraine, introduced to Southwest Indian tribes by early Spanish missionaries, was popular among the Pueblo Indians because it resembled a dragon-fly. The sacred heart motif was viewed as a new moon symbol.

A Zuni water serpent called *Kolowisi*.

Serpent design from Casas Grandes.

The water serpent, known in Tewa as *Avanyu*, has lightning originating from its mouth, a cloud symbol attached to its horn, and another resting above its back. At Hopi, he is called *Palalonkon*.

Nearly seventy-five years ago, three men from San Ildefonso variously identified this pottery design band as: a leaf and cloud, clouds and rain going in two directions and simply as fog.

A red and black Zuni pottery design that symbolizes clouds coming together.

This San Ildefonso design represents either a star or star with clouds. In the 1920s a man from that village said the star was composed of leaf and step designs, while in 1992 a potter identified the elements as birds and clouds.

Closely resembling both water and gnela designs, this represents clouds being blown away.

Rain cloud motifs.

A Zuni design from the rim of a bowl, said to represent waves.

This raincloud resembles the tabletas or headpieces worn by certain Pueblo Indian religious dancers.

Clouds with either rain, snow or hail, depending upon one's viewpoint. From San Ildefonso pueblo.

An early anthropologist recorded this design as representing pueblo according to one individual and a cloud with rain flanked by light clouds on the left, according to another.

San Ildefonso cloud and rain or cloud and bird motif.

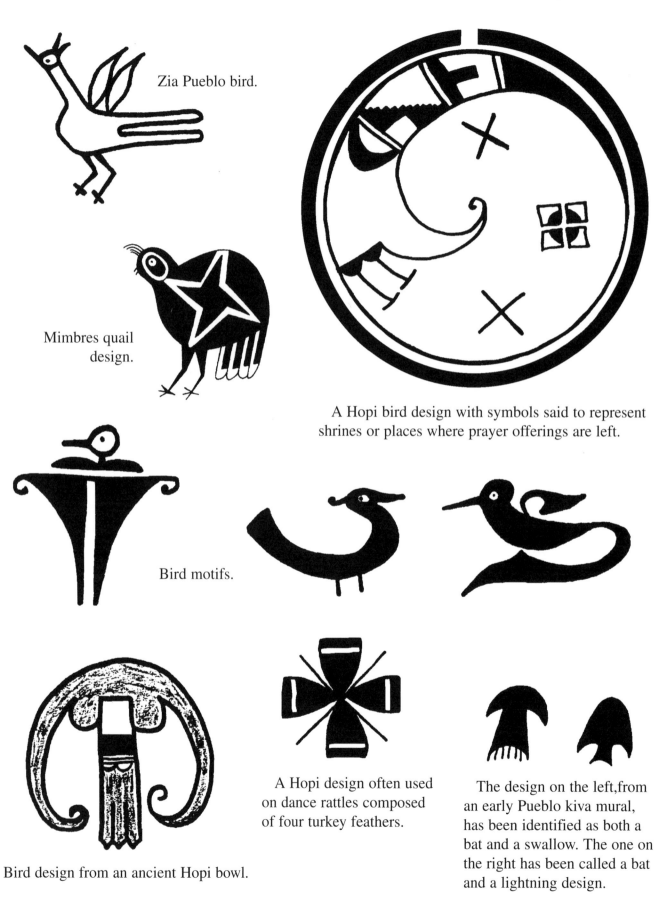

Zia Pueblo bird.

Mimbres quail design.

A Hopi bird design with symbols said to represent shrines or places where prayer offerings are left.

Bird motifs.

Bird design from an ancient Hopi bowl.

A Hopi design often used on dance rattles composed of four turkey feathers.

The design on the left, from an early Pueblo kiva mural, has been identified as both a bat and a swallow. The one on the right has been called a bat and a lightning design.

Pueblo petroglyph.

A Zuni cloud motif with dragonflies. According to some, the polliwog was a design that represented early summer, the dragonfly was for mid-summer and the frog for late summer.

Turtle holding a cloud.

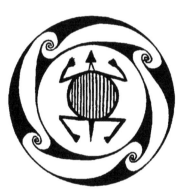

Mimbres turtle design.

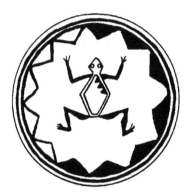

Mimbres frog design.

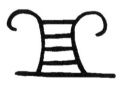

A Zuni design said to be a type of inchworm found near springs in the area.

Hohokam water bird. Powerful summer storms from the Pacific Coast blow sea birds to Arizona desert regions. This design could represent one such bird or a water-bird that was native to Arizona when there were many more active streams and rivers.

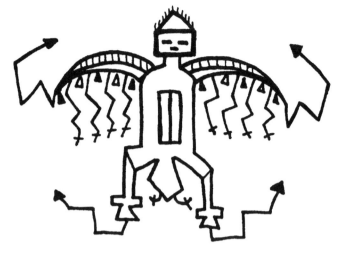

In Navajo sandpainting, this represents female lightning. In Pueblo Indian usage no gender is attached.

Ikne Tso, Big Thunder, appears in Navajo sandpaintings. Lightning flashes out from his body and rain and cloud symbols are used in his wings. He wears a cloud cap, has cloud feet and a rainbow bar on his chest.

A Navajo design said to represent male lightning, with symbols on the arrow points showing that it includes both straight and crooked lightning.

The wingtips of the birds each touch a cloud and the clouds are connected by lightning.

Sometimes called a Knife Wing dancer, this Zuni figure is called *Atchialahtopah*, or Knife-feathered Being, a Zuni war god.

A Zuni Thunderbird design. It has been suggested that the Thunderbird is derived from the Nighthawk,which makes a deep whirring or roaring sound as it pulls out of a steep dive. Others feel that it is a stylization of Atchialahtopah.

This design was in the 1920s identified by a Zuni as arrow points coming together. When they come together, the fighting stops - a prayer for the end of war.

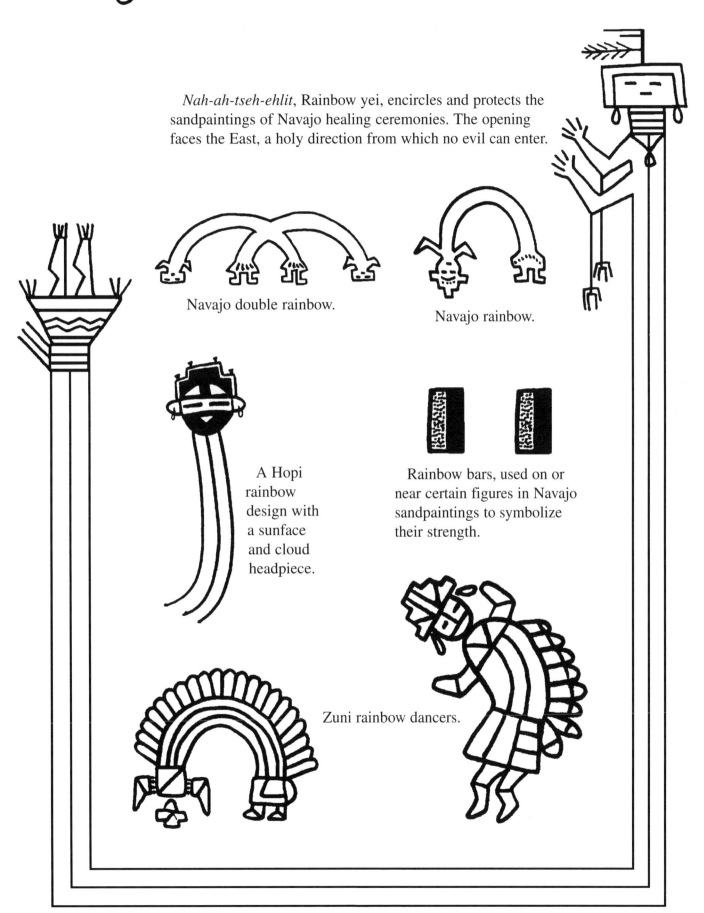

Nah-ah-tseh-ehlit, Rainbow yei, encircles and protects the sandpaintings of Navajo healing ceremonies. The opening faces the East, a holy direction from which no evil can enter.

Navajo double rainbow.

Navajo rainbow.

A Hopi rainbow design with a sunface and cloud headpiece.

Rainbow bars, used on or near certain figures in Navajo sandpaintings to symbolize their strength.

Zuni rainbow dancers.

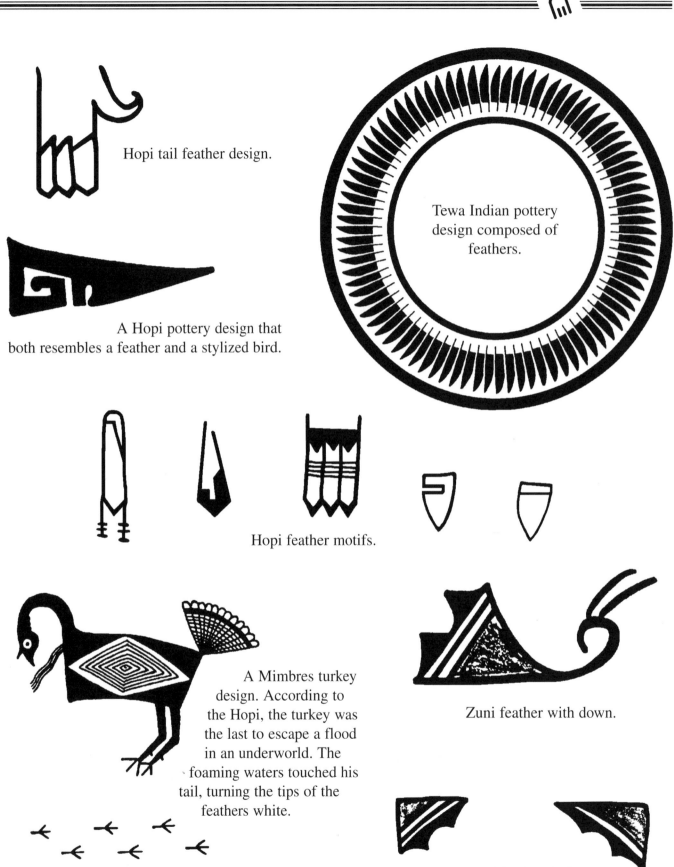

Hopi tail feather design.

Tewa Indian pottery design composed of feathers.

A Hopi pottery design that both resembles a feather and a stylized bird.

Hopi feather motifs.

A Mimbres turkey design. According to the Hopi, the turkey was the last to escape a flood in an underworld. The foaming waters touched his tail, turning the tips of the feathers white.

Zuni feather with down.

Two Zuni feather designs.

24

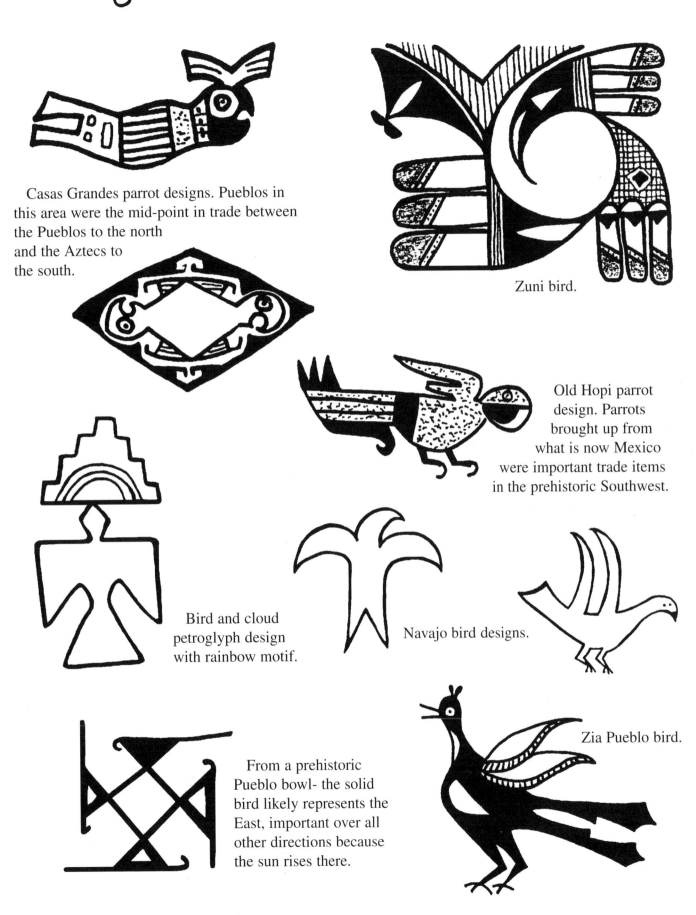

Casas Grandes parrot designs. Pueblos in this area were the mid-point in trade between the Pueblos to the north and the Aztecs to the south.

Zuni bird.

Old Hopi parrot design. Parrots brought up from what is now Mexico were important trade items in the prehistoric Southwest.

Bird and cloud petroglyph design with rainbow motif.

Navajo bird designs.

Zia Pueblo bird.

From a prehistoric Pueblo bowl- the solid bird likely represents the East, important over all other directions because the sun rises there.

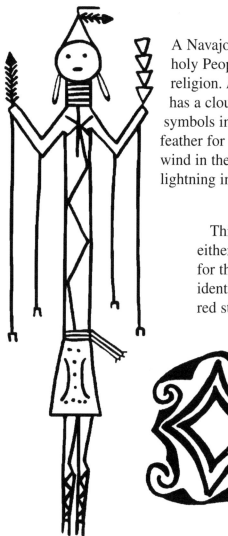

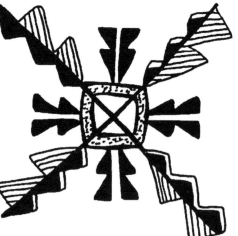

A Navajo *yei*, one of the holy People of Navajo religion. *Niltsi*, Wind yei, has a cloud cap, cloud symbols in one hand, a feather for creating the wind in the other, and lightning in his body.

This Zuni design appears to be either clouds or clouds and feathers for the four cardinal directions. One Zuni man in the 1920's identified it as a ceremonial blanket design. Another said it represented red steps and striped steps with a checked square in the middle.

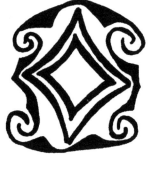

A Zuni design variously recognized as a rain blanket, rain clouds coming together from all directions and as a prayer for rain. It contains four apparent netsika designs, though designs can be more than or even other than the sum of their parts.

A stylized bird carrying a cloud symbol on its back.

A Zuni pottery design identified as both a prayer for rain on the fields and as netsika and a star.

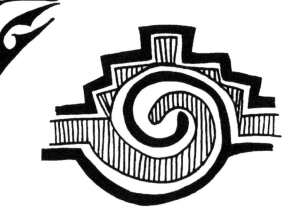

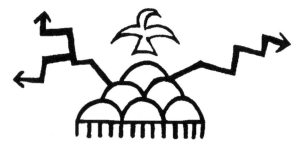

This Pueblo raincloud contains one cloud for each of the six directions.

The ancient Tularosa pottery design is believed to be a stylized rain bird. It incorporates symbols often identified as rain and clouds.

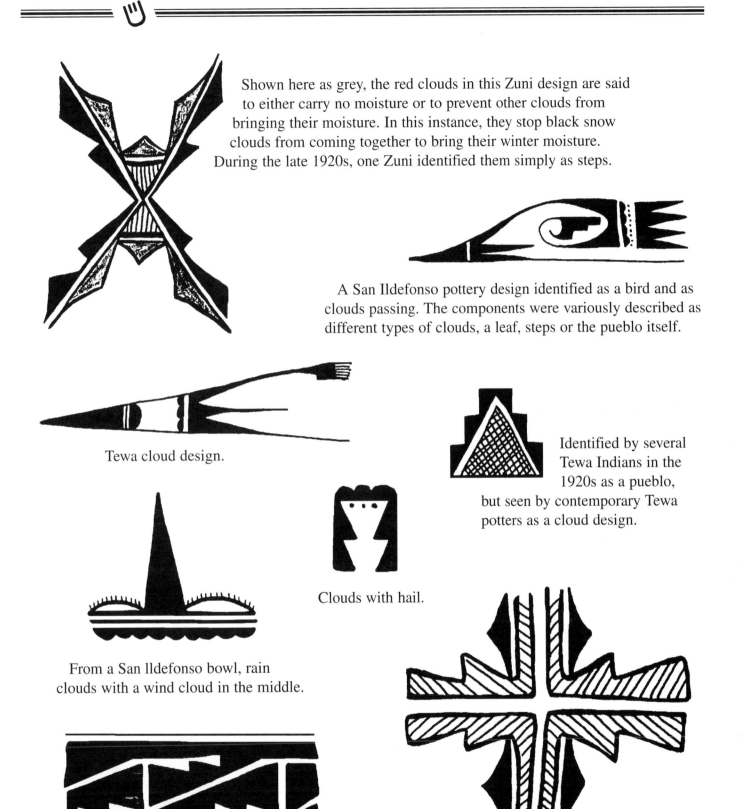

Shown here as grey, the red clouds in this Zuni design are said to either carry no moisture or to prevent other clouds from bringing their moisture. In this instance, they stop black snow clouds from coming together to bring their winter moisture. During the late 1920s, one Zuni identified them simply as steps.

A San Ildefonso pottery design identified as a bird and as clouds passing. The components were variously described as different types of clouds, a leaf, steps or the pueblo itself.

Tewa cloud design.

Identified by several Tewa Indians in the 1920s as a pueblo, but seen by contemporary Tewa potters as a cloud design.

Clouds with hail.

From a San Ildefonso bowl, rain clouds with a wind cloud in the middle.

This San Ildefonso design from a pottery vase, representing clouds, is also used on some Pueblo woven belts.

On Zuni pottery, half the design is in black and the other half is in red. Said to represent clouds struggling.

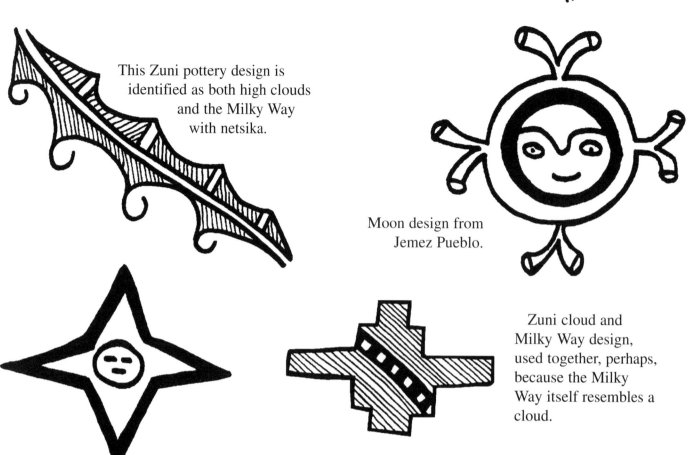

This Zuni pottery design is identified as both high clouds and the Milky Way with netsika.

Moon design from Jemez Pueblo.

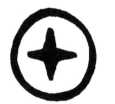

A star design used on some Hopi dance rattles and on the face of the *Ngasohu* or Shooting Star katsina.

Zuni cloud and Milky Way design, used together, perhaps, because the Milky Way itself resembles a cloud.

The black and white bar in this Zuni design represents the Milky Way. Clouds are on each side.

This star design is from Jemez Pueblo. Yellow was used for the Evening Star, the planet Venus, and red for the Morning Star, the planet Mars.

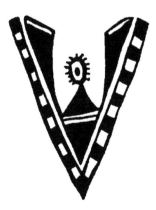

In Navajo sandpaintings of Father Sky, an interlocking zig-zag design is used to symbolize the Milky Way.

A Zuni design once used as a prayer that the stars in the Milky Way would keep the sky bright at night.

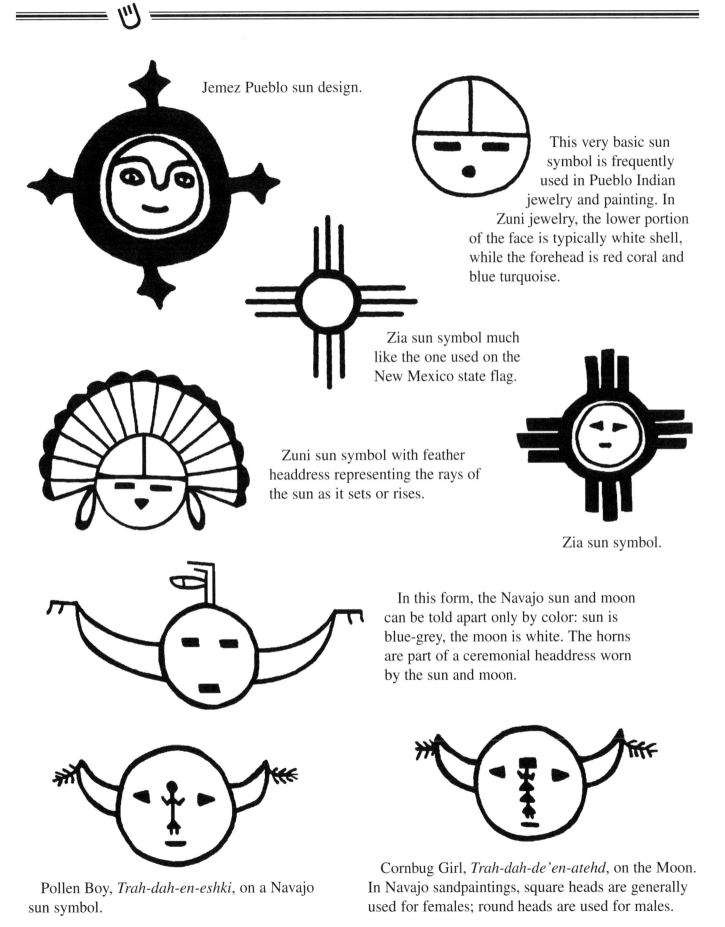

Jemez Pueblo sun design.

This very basic sun symbol is frequently used in Pueblo Indian jewelry and painting. In Zuni jewelry, the lower portion of the face is typically white shell, while the forehead is red coral and blue turquoise.

Zia sun symbol much like the one used on the New Mexico state flag.

Zuni sun symbol with feather headdress representing the rays of the sun as it sets or rises.

Zia sun symbol.

In this form, the Navajo sun and moon can be told apart only by color: sun is blue-grey, the moon is white. The horns are part of a ceremonial headdress worn by the sun and moon.

Pollen Boy, *Trah-dah-en-eshki*, on a Navajo sun symbol.

Cornbug Girl, *Trah-dah-de'en-atehd*, on the Moon. In Navajo sandpaintings, square heads are generally used for females; round heads are used for males.

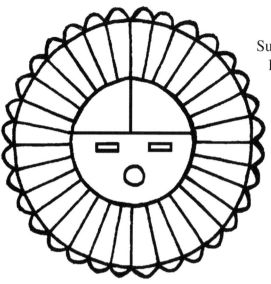

Sun with feathers representing the rays of the sun. In most Pueblo Indian cultures the rising sun is greeted with prayer each day. Sunrise, itself, is broken down into several phases: beginning with white dawn; yellow dawn, the sun's forehead; and full sunrise.

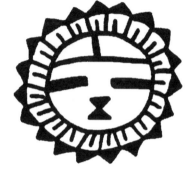

Hopi sun face.

Hopi sun design reminiscent of a flower or sunflower motif.

Hopi sun or *Tawa*.

Early Hopi sun symbol.

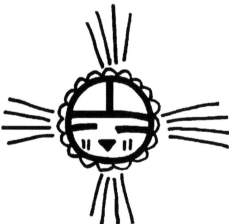

Hopi sunface with hunter marks on his cheeks and a halo-like ring between the face and directional sunbeams.

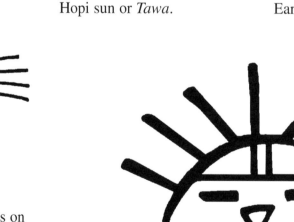

Hopi petroglyph design of a rising/setting sun.

Identified at Acoma as a cloud string or a cloud band.

Clouds coming together. (Acoma)

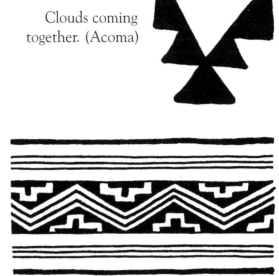

Three-quarters of a century ago, ethnologist Ruth Bunzel recorded a Zuni potter as saying this design was a labyrinth and that it represented "a prayer that the Navajo may not find us in war. A prayer for safety." Another said the motif consisted of four cloud designs kept from coming together by the black lines.

Trying to determine what if any meaning or representation there is behind a design is risky and difficult at best. Terraced or stepped patterns are often used to symbolize clouds. Zigzag lines may be used for lightning. But does that mean that this design—found in both Navajo weavings and ancient pueblo pottery—represents clouds and lightning? Or that the four lines (three light and one heavy) have to do with three underworlds and the Fourth World? Or flowing water? We are on safer ground if we try and determine what it means to us, here and now—and acknowledge that in any given culture a design will have shades of meanings—perhaps even dramatically different meanings, among the people of that culture and that those meanings usually shift over time. (*This would be a good time to read the introduction if you skipped it the first time through!*)

These hurunkwa feathers are worn on the tops of the heads of Hopi katsinas regarded as hunters or warriors. The parallel marks represent the same and are found on the faces of some of those same katsinas.

At Hopi the lower undulating design with the hurunkwa is used in connection with snake imagery, while the top one with the 'v' shaped marks are associated with the water serpent—Paalölöqanw.

This image is identified as a moon and star. A number of stars (planets actually) appear close to the moon from time to time. At Hopi the star in this design is generally identified as either Venus or Mars and can be found on Sotunangu (translated as Sky God) and Chakwaina (a warrior katsina).

Hanging feathers—Acoma.

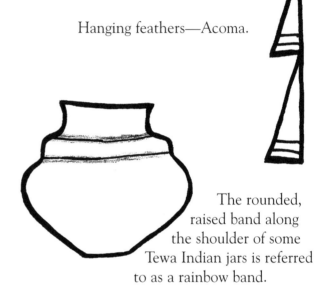

A Hopi design representing rain. How a band of alternating black and blocks came to represent clouds can be understood if one looks to the south from the Hopi mesas and watches a storm come up over the Mogollon Rim.

The rounded, raised band along the shoulder of some Tewa Indian jars is referred to as a rainbow band.

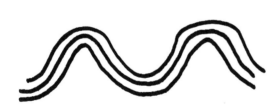

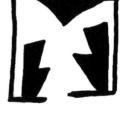

Snow in the clouds. (Acoma)

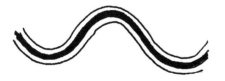

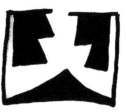

A red and black Zuni pottery border design said to be clouds coming together.

Whether joined together or separated, a pair of undulating parallel lines are generally identified by pueblo potters as a rainbow motif.

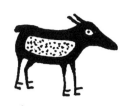

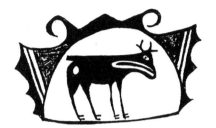

Zuni fawn.

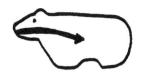

The bear's position or significance varies greatly from one tribe to the next. Among the Zuni it is the second most powerful animal: among the Navajo he is the most powerful one. Among many pueblos he is associated with healing of serious injuries.

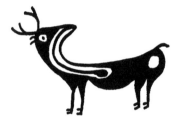

Deer's house—a Zuni pottery design.

Variations of 'heartlines' that may appear on animal images to indicate the design represents a living animal. Often seen on modern Zuni animal carvings, there is no word for the symbol in Zuni, but there is general agreement that it represents the thorassic organs: the heart and lungs as well as the esophagus.

A Zuni deer design with a breath or spirit line. Sometimes referred to as a heartline, Zuni women potters interviewed by the ethnologist Ruth Bunzel early in this century, told her that the line was meant to show that they were illustrating a living animal. To do otherwise would jeopardize the men's success in hunting. In recent years variations of this line have come to be used and prominently featured on stone and shell animal carvings commonly called 'fetishes'.

A Zuni deer in a 'house of flowers'.

Zuni image of a mountain lion.

Many tribes in the Southwest looked at the moon and saw not the European Man in the Moon but a rabbit (a vision shared by the Chinese).

Turkey tracks, a symbol often used on Hopi rattles.

This rabbit is standing over what is probably a staff of authority—perhaps similar to the gnela described and illustrated earlier in this book. A prominent Hopi artist, Fred Kabotie, suggested that the lines indicate that it is a chipped stone blade—used by members of the Rabbit Clan to protect the village.

Turkey feathers— which may be used in pueblo prayer offering.

These elongated 'X's represent the tracks of a Southwestern bird called the roadrunner or Chaparral Cock. In some instances it is associated with war practices as the track does not readily reveal the direction of travel.

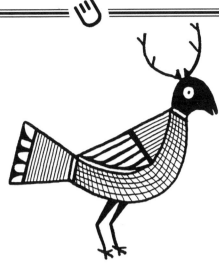

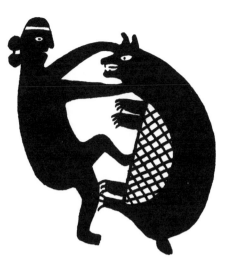

Ancient Indian pottery by the peoples we call Mimbres includes some rather fantastical creatures. Some mix fish, bird and insect attributes while others mix bears or mountain lions with fish and deer. What this bird-deer may have represented we can only guess.

These two Mimbres pottery designs appeared on the same bowl. No one can say if they represent an unfortunate hunting party, a ritual or a mythological story. For that matter we don't know if they represent men wrestling bears or bears wrestling men......

Two-headed animals may represent a range of things—from a natural oddity to two animals passing each other going in opposite directions. It has also been suggested that this petroglyph represents a mountain sheep giving birth.

These designs have been identified as humans, lizards and dancers. They have also all been tentatively identified as 'water skates'—small long-legged bugs that can move about on the surface of the water. The beliefs of a few tribes associate the little insect with the four directions or as symbolizing those directions.

These prehistoric pueblo images—a pictograph (a painted image) from southeastern Utah, and petroglyph (an image pecked into the rock) with an apparent horned headdress, from the Galisteo Basin or New Mexico, represent warriors with shields.

This petroglyph from southern Arizona is believed to represent a birth scene, with mother, infant, umbilical cord and placenta. The 'what' of an image can be easier to determine or make an educated guess at than the 'why' of an image.

Was this petroglyph created because the site was a place of prayer related to safe childbirth, to commemorate the birth of humankind in the tribe's Creation Story or was some parent moved by the miracle of birth to express it as rock art?

Context is a crucial clue to identifying images. This face appears on both the male and female *Sa'lako* katsinas of the Hopi. The male Sa'lako has a pink face and the female a white face. This is also the face of the *Palhikwmana* or Butterfly Maiden katsina—only the clothing differentiates it from the female Sa'lako.

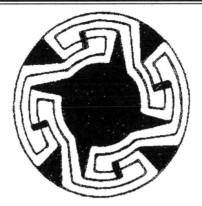

Sivalik or whirlwind is the name in the Pima language for this basketry design.

Muyyungyapu is the Hopi name for willow wicker plaques with a crescent moon design.

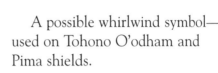

A possible whirlwind symbol—used on Tohono O'odham and Pima shields.

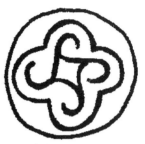

It can be misleading to use native words for designs without being certain of their exact usage. *Potayngyapu* is the Hopi name for willow wicker baskets with this design only, but it is *not* the name of the design.

Though it bears a strong resemblance to a whirlwind motif, a Hopi willow wicker basket with this design is called *Pi'akyungyapu*, which is a combination of their word for a basket of willow wicker construction and the name for caterpillar—*pi'ak*—in it. Whether the intent to represent a caterpillar or its mode of travel inspired the pattern or whether the pattern came first and the description or name came afterward, we cannot be certain.

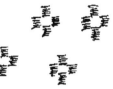

A Pima basket design first recorded as being identified as a butterfly design nearly a century ago.

A Mescalero Apache basket design identified by Mescalero Apache medicine man Bernard Second, as representing Old Man Lightning.

Above are coyote tracks and at right dragging coyote tracks—from a very tired coyote. Tohono O'odham basket motifs.

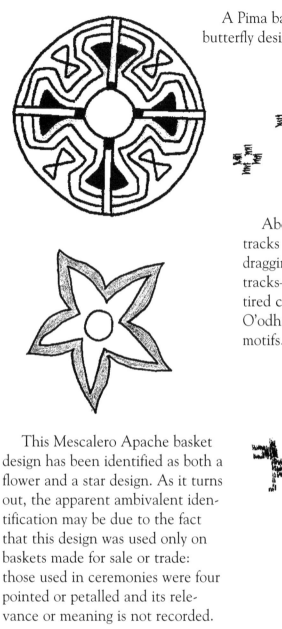

This Mescalero Apache basket design has been identified as both a flower and a star design. As it turns out, the apparent ambivalent identification may be due to the fact that this design was used only on baskets made for sale or trade: those used in ceremonies were four pointed or petalled and its relevance or meaning is not recorded.

This Hopi basket design represents an antelope.

A Tohono O'odham basket weaver identified these designs (from left to right) as a scared (barking) puppy, a barking dog, a coyote, and two horses.

A Pima basket design referred to as a squash petal design. This one is a four-petal design, while below it is a 10 petal design.

Above is a Tohono O'odham (relatives of the Pima) basket design called a 'turtle back' design. If you study it closely you will see that the squash petal and turtle back designs draw from the same geometry, with the latter being a more 'segmented' form.

This basketry design falls somewhere between the squash blossom and turtle back designs, but does not currently have a name.

Some rug weavers call this a *bee ha'nilchaadí* or carding comb design.

Another rug design called *tsiiyé* after the traditional Navajo hairstyle.

When appearing by itself in a rug design this motif has been identified as a backbone design because it resembles the spine.

Two variations of the Spiderwoman cross sometimes used in Navajo weaving designs— both baskets and blankets or rugs.

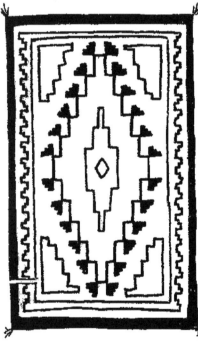

Regional patterns on Navajo weavings began in the 1920's and ended in the 1950's. Though the names still persist—Ganado Reds, Crystal, Two Grey, Teec Noc Poc—the rugs may be woven anywhere. This geometric pattern is used in Ganado (red, black, grey and white) and Two Grey Hill (black, white, grey and brown) weavings. In one corner a line runs out from the background to the edge of the rug. Called a 'spirit line' there are many fanciful stories about why they are sometimes used. Among the weavers who use them there are a range of explanations given, from the optimistic "so it won't be perfect" to the pragmatic "it sells better." A Navajo professor of art explained it best by saying that in a complex symmetrical design the eye goes back and forth looking for the asymmetry— a place to rest as it were. The line out provides that—essentially 'freeing' the eye.

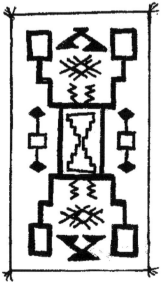

An early Navajo regional style weaving called a Storm Pattern. The stepped patterns running out to each corner are said by some to represent lightning and the central area can be thought of as a cloud, though the evidence suggests the pattern came first and the name later.

Often called a wedding basket, both Navajo and Paiute weavers use this design. More accurately called a ceremonial basket, it is often used by Navajo hataali or medicine men to hold corn meal for blessings or prayers. Whether in use or in storage, the opening must face east— a direction from which no evil can enter the basket, polluting the sacred corn meal (sacred because it has been blessed). While the gap has an important function, its existence is due to an artist's 'trick'. A coiled basket is created by a spiraling coil which makes a perfect circle impossible (see illustration below). By breaking the circle before it closes or completes, you can fool the eye into assuming the circle is symmetrical.

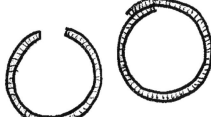

A design break in a Santo Domingo Pueblo pottery motif. When pottery was developed in the Southwest (many hundreds of years after basketry) artisans in many cultures carried the design break over into their pottery. Even though it was no longer technically necessary, the design break had become a part of the artists' way of designing.

A design break in a Hopi pottery design, which is not often used, whereas at Santo Domingo pueblo potters always employ it.

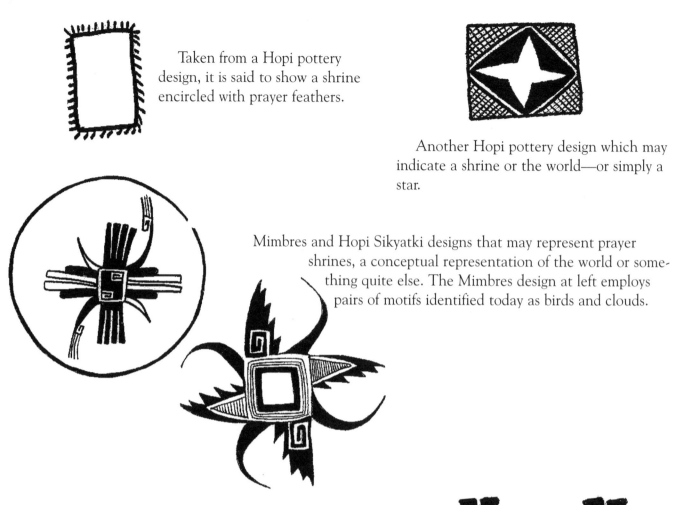

Taken from a Hopi pottery design, it is said to show a shrine encircled with prayer feathers.

Another Hopi pottery design which may indicate a shrine or the world—or simply a star.

Mimbres and Hopi Sikyatki designs that may represent prayer shrines, a conceptual representation of the world or something quite else. The Mimbres design at left employs pairs of motifs identified today as birds and clouds.

This Zuni pottery design very closely resembles those that have been identified in Hopi pottery as prayer shrines, especially with the feather motifs. But three-quarters of a century ago at Zuni it was identified by a potter as a blanket or manta similar to the one worn by the katsina Talavai'i. Has the significance changed or was the potter resisting an ethnologist's probing?

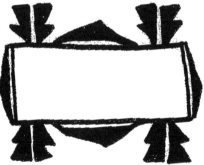

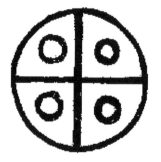

This Hopi design is said to represent the four directions or the world (the world generally or the land of the Hopi, depending upon who you talk to) divided into quadrants by the four directions. Some say it symbolizes the four worlds—the three underworlds from which the Hopi emerged and the present or Fourth World.

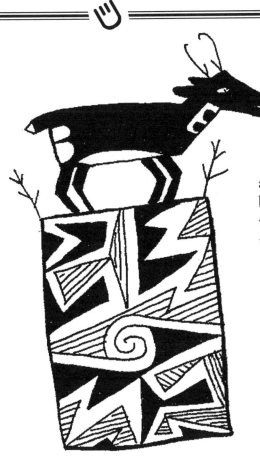

This Mimbres pottery design of a male antelope is standing atop a rectangle that some present-day Pueblo philosophers believe may represent the land on which the antelope lives, with the two plant motifs at each corner symbolizing the food they graze upon.

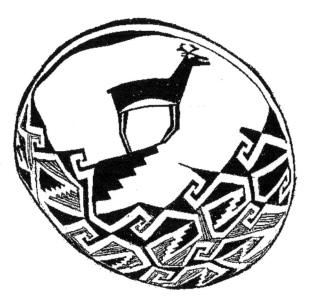

Another Mimbres bowl design of an antelope with geometric designs used to symbolize the natural world.

Bunzel recorded this design, originally executed in black and red, as being a snow blanket—a prayer to bring moisture to the winter gardens. One Zuni potter told her that the men could make prayer offerings in the kivas, but that the women made theirs with designs on their pottery.

Many Southwest Indian designs have been adopted and used by others. The most famous example is the New Mexico state flag, which utilizes the Zia sun symbol shown elsewhere in this book. Other examples include this Hopi pottery design, copied precisely from a bowl by the renowned Hopi potter Nampeyo and copyrighted by the Fred Harvey Company in 1904.

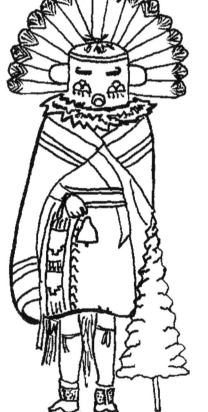

The Hopi Talavai'i or Early Morning katsina was protected for the exclusive use of a financial institution which obtained a copyright or trademark for it. It was later sold the rights to the image—along with its name—to another bank. The bitter irony is that Hopi Tribe has been rebuffed in its efforts to protect images of katsinas through the law.

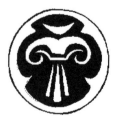

A part of the Museum of Northern Arizona's early mission was the encouragement of Hopi arts and the development of a market for them. A variation of this Hopi pottery design was adopted for use as the logo of the museum and the image is legally protected for the benefit of the institution.

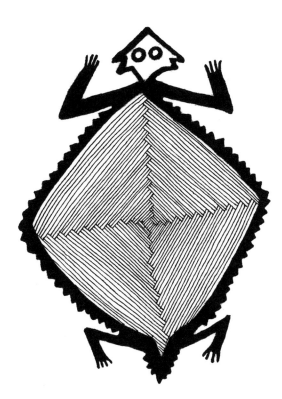

A Hohokam shell frog design.

Images of horned lizards, like this one from a Hohokam pottery design, usually have serrated edges that prevent them from being mistaken for frogs.

A Hopi petroglyph symbol said by an early ethnologist to represent a whirlwind deity.

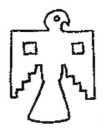

This image, taken from jewelry designed by non-Indians for the non-Indian market in the early 1900's, has been identified as both a horse and a dog.

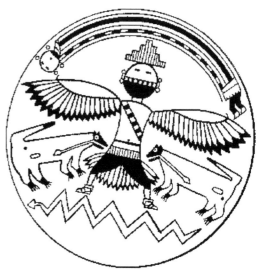

Variations of Hopi bird designs were used as logos by the Fred Harvey Company as was the Zuni shield design at right. C.G. Wallace, a prominent trader at the pueblo of Zuni, also used this Zuni design in his business. Many traders employed such religious symbols on their business stationery and the practice continues today, among both non-Indian and Indian-owned businesses.

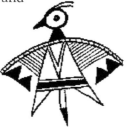

As we have seen, the meaning of symbols varies according to cultural context. But beyond that there is a point where nature, art and science intersect.

This design, reminiscent of design elements found in Pueblo pottery, is actually a "phase space representation of the dissipative linear pendulum" and comes from an illustration from a book by professors Baker and Gollub entitled *Chaotic Dynamics*.

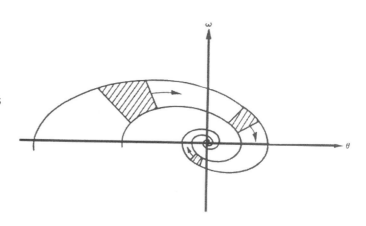

ANNOTATED BIBLIOGRAPHY

Appleton, Le Roy H. *American Indian Design and Decoration*. New York: Dover Publications, 1971.

Bahti, Tom. *Southwestern Indian Ceremonials*. Las Vegas: KC Publications, 1970.
 With the exception of a few photographs, this book is illustrated with paintings by artists from the various Southwestern tribes. The text provides an introduction to the religions and philosophies of those tribes. A suggested reading list at the end provides direction for those who may wish to learn more.

Baylor, Byrd. *Before You Came This Way*. New York: E. P. Dutton & Company, 1969.
 This sensitively-written book of prose-poetry is illustrated with designs adapted from petroglyphs in the Southwest.

_____. *When Clay Sings*. New York: MacMillian Publishing Company, 1972.
 As above, but focusing on ancient Indian pottery designs.

Broder, Patricia Janis. *Hopi Painting in the World of the Hopis*. New York: E.P. Dutton Company, 1978.
 This well-illustrated volume provides an excellent history of the evolution of Hopi painting, its sources and meanings.

Brody, J. J. *Anasazi and Pueblo Painting*. Albuquerque: University of New Mexico Press, 1991.
 An interesting and profusely illustrated discussion of the history and place of painting in ancient Pueblo life.

_____. *Mimbres Painted Pottery*. Albuquerque: University of New Mexico Press, 1977.
 Includes continuation of discussion of pottery tradition as it exists today.

Bunzel, Ruth. *The Pueblo Potter: A Study of Creative Imagination in Primitive Arts*. New York: Dover Publications, 1972.
 This reprint of a 1929 Columbia University Press edition is an excellent exception to the block of books on Indian art by authors who fail to talk to the Indian artists before writing about or attempting to interpret Indian art.

Hibben, Frank C. *Kiva Art of the Anasazi*. Las Vegas: KC Publications, 1975.
 Painted reproductions of kiva murals unearthed in northern New Mexico provide the focus for this book, which includes an anthropologist's discussion and analysis of the images along with information provided by some of the Pueblo tribes of the region.

Kabotie, Fred. *Designs from the Ancient Mimbrenos with a Hopi Interpretation*. Flagstaff: Northland Press, 1982.
 The title says it all.

Lister, Robert H. and Florence C. *Anasazi Pottery*. Albuquerque: University of New Mexico Press, 1978.
 Ten centuries of pottery from the region are illustrated with an excellent text.

Mera, Harry P. *Indian Silverwork of the Southwest Illustrated*. Globe, Arizona: Dale Stuart King Publisher, 1959.
 Photographic survey of silver jewelry from its inception to the 1940s.

Naylor, Maria, ed. *Authentic Indian Designs*. New York: Dover Publications, 1975.
 Reproductions of some 2500 photos, engravings, and drawings from the Bureau of American Ethnology reports.

Otten, Charlotte M. *Anthropology and Art: Readings in Cross-Cultural Aesthetics*. New York: The Natural History Press, 1971.
 A very good starting point for someone who wishes to read about cross-cultural issues in art.

Reichard, Gladys A. *Navajo Religion. Volumes I and II*. New York: Pantheon Books, 1950.
 This excellent study provides the religious context for many of the Navajo symbols one sees in Navajo sandpainting.

Schaafsma, Polly. *Indian Rock Art of the Southwest*. Albuquerque: University of New Mexico Press, 1980.
 Excellent text, well-illustrated with photos and drawings.

Sibett, Jr., Edward. *American Indian Cut and Use Stencils*. New York: Dover Press, 1981.

Sides, Dorothy. *Decorative Art of the Southwestern Indians*. New York: Dover Press, 1961.
 Illustrations with a little bit of informative text.

Wilson, Eva. *North American Indian Designs for Artists and Craftspeople*. New York, Dover press, 1987.

Young, M. Jane. *Signs From the Ancestors*. Albuquerque: University of New Mexico Press, 1988.
 Ms. Young, with the help of the Zuni people writes of Zuni cultural symbolism and rock art found within the traditional homeland of the Zuni. Illustrated with drawings and photographs.